Creative Watercolour
Techniques

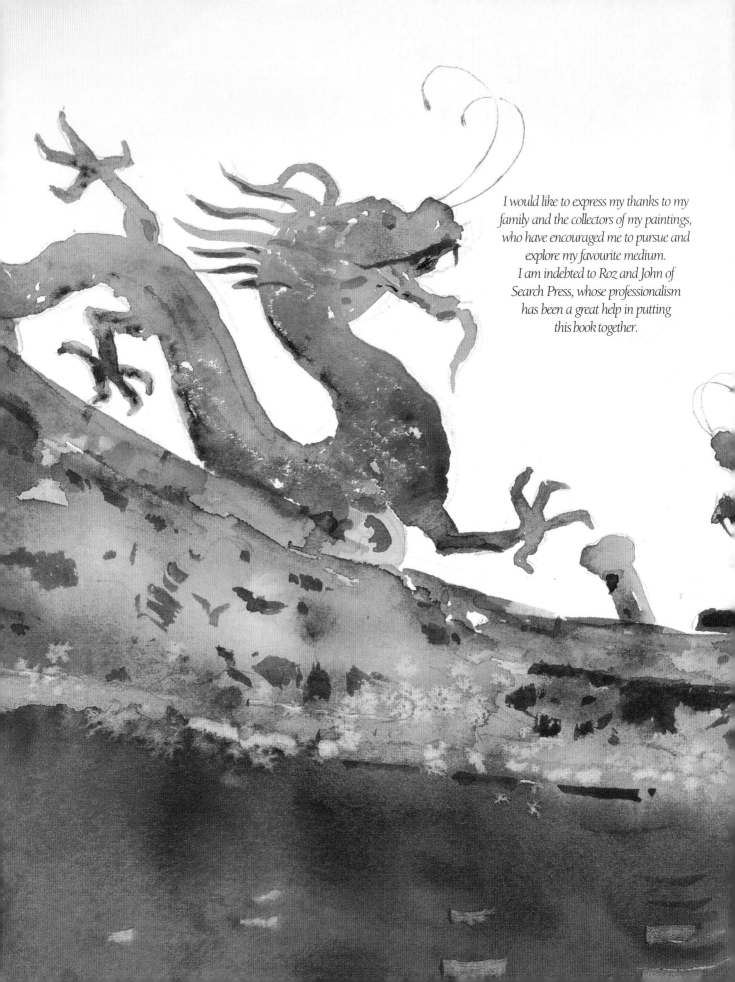

I would like to express my thanks to my family and the collectors of my paintings, who have encouraged me to pursue and explore my favourite medium. I am indebted to Roz and John of Search Press, whose professionalism has been a great help in putting this book together.

Creative Watercolour Techniques

RICHARD BOLTON

SEARCH PRESS

First published in Great Britain 2000

Search Press Limited
Wellwood, North Farm Road,
Tunbridge Wells, Kent TN2 3DR

Reprinted 2001, 2002

ISBN 0 85532 847 9

The Publishers and author can accept no
responsibility for any consequences arising
from the information, advice or instructions
given in this publication.

The Publishers and author would like to
thank Winsor & Newton for supplying many
of the materials used in this book.

Suppliers

If you have difficulty in obtaining any of the
materials and equipment mentioned in this
book, then please visit the Search Press
website for details of suppliers:
www.searchpress.com

Alternatively, you can write to the Publishers
at the address above, for a current list of
stockists, including firms who operate a mail-
order service, or you can write to Winsor &
Newton requesting a list of distributers.

Winsor & Newton, UK Marketing
Whitefriars Avenue, Harrow,
Middlesex, HA3 5RH

Publishers' note

All the step-by-step photographs in this
book feature the author, Richard Bolton,
demonstrating his watercolour
techniques. No models have been used.

Colour separation by Graphics '91 Pte Ltd, Singapore
Printed in Spain by A. G. Elkar S. Coop. 48180 Loiu (Bizkaia)

Page 1
Overgrown Gateway
260 x 310mm (10¼ x 12¼in)

*When painting brickwork, pay attention to
detail. In this painting, the variation in the
colour of the bricks and the irregularity of
the gaps in the mortar combine to draw the
eye to the bricks, to impart scale and to add
to the rustic charm of the subject.*

Page 2–3
Rooftop Dragons
405 x 260mm (16 x 10¼in)

*I included some acrylic ink in this painting,
mixing bright yellow and some black with
the watercolours, to give a lively quality to
the picture. Acrylic inks can be very vibrant,
and they provide an avenue for
experimentation.*

Opposite
Minchin Forestry Recreational Park, Taiwan
335 x 500mm (13¼ x 19¾in)

*Water is a favourite subject of mine, and I
enjoy the challenge of capturing its natural
beauty. The deep colours in a lake, for
example, can be difficult to achieve without
them becoming dull and overworked. For
this scene, I applied a number of washes to
build up the dark rich tones, but I had to be
careful to avoid forming hard edges or
causing the previous wash to run.*

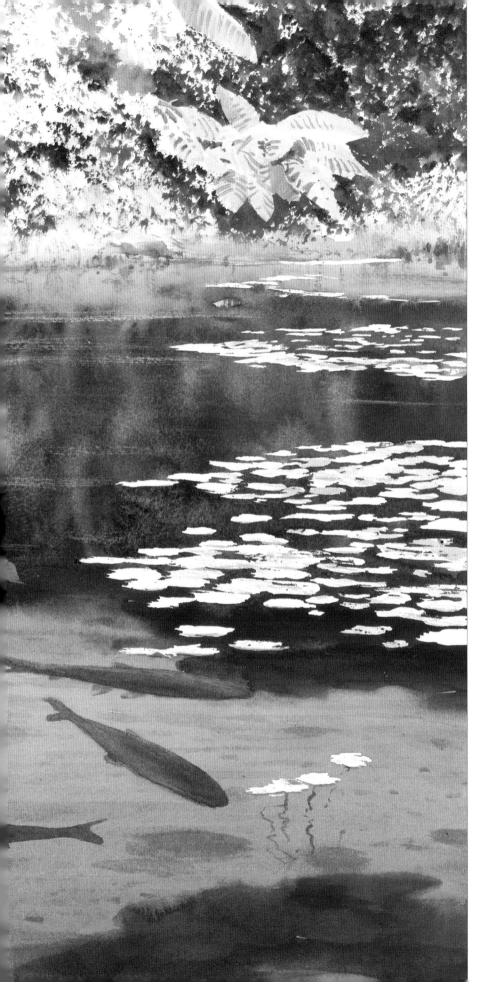

Contents

Introduction

There is a long tradition associated with watercolour painting. Very early paintings tended to be drawings, with pale washes applied to create tone and form. Later, in the eighteenth and nineteenth centuries, when it became fashionable to go on the 'Grand Tour' of classical cities – Rome, Venice and Naples – watercolour artists were taken along to capture scenes on paper, rather as we take a camera on holiday. The artist would often give lessons to his host, and painting with watercolours became popular across a broad spectrum of society. With this popularity, and the ever-increasing prosperity of the Victorian era, came a demand for paintings to grace the walls of the successful industrialists. It was a good time to be a painter, and the skills of the watercolourist developed enormously. Styles varied greatly, and some painters used the medium with such vibrancy that they challenged oil paintings for strength.

When you first start painting, it always helps to look at the work of established artists for inspiration and to give you direction. Some painters are *pure* watercolourists – nothing must be introduced to adulterate their colours – others, like myself, will use other techniques if they help the painting. My style has been developed over many years. When I first started painting, I followed the 'rules' and created loose transparent images. However, I soon found that I wanted to take my paintings further, so I have gradually introduced different techniques to add texture and complexity to my pictures.

Problems multiply with size, and it takes time to understand the limitations of watercolours. Every brushstroke counts and demands your full attention so, when you introduce a new technique to your skills, practise on small paintings. Do not give up on a painting too soon – things are bound to go wrong – but try to learn from your mistakes. If you feel that a painting has become dull and overworked or it just looks a mess, instead of throwing it away, take a sponge, wash as much paint off as possible and let it dry out. You will will be left with a very pale version of your original painting that you can paint over and then, perhaps, create a masterpiece.

In this book I show some of the techniques I use in my paintings, and I hope they will prove exciting and challenging. Do not over use them in your paintings; there is a fine balance to achieve, especially when one wishes to retain the fluid characteristic of the medium. Be a harsh critic of your own work, always look for improvement and, gradually, your skills and confidence will grow.

Opposite
Old Oak
230 x 260mm (9 x 10¼in)
Wax resist was used to create the patchy, irregular surface of the bark on this old tree. A very fluid mix of paint was then brushed on and allowed to bead and pool into natural patterns on the paper. A fluid mix was also applied to the foreground, then I waited until the paint was almost dry before using the corner of a razor blade to scratch out the stems of grass.

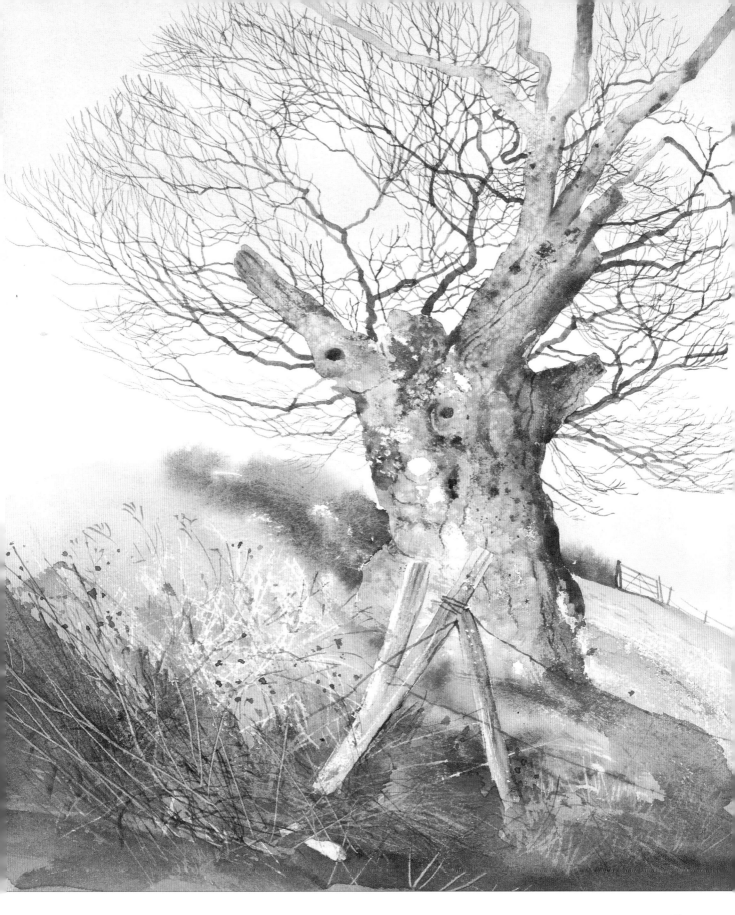

Materials

One of the charms of watercolour painting is the basic simplicity of the materials. Some paints, a few brushes and a jar of water are all you need to paint a fine picture. There is a wide variety of painting sets available to get you started, just choose one that will give you space to add more colours as you gain experience.

My paint tin

My tin of paints is rather ancient, but it still serves its purpose well (despite the fact that my brushes have scrubbed through the white enamel of the mixing tray). The paint section takes two rows of pans which I fill with half pans or full pans as I feel fit. The central aisle,

You can buy tiny compact sets of paints that are ideal for carrying on holidays. Even so, my larger tin of colours still fits in my pocket.

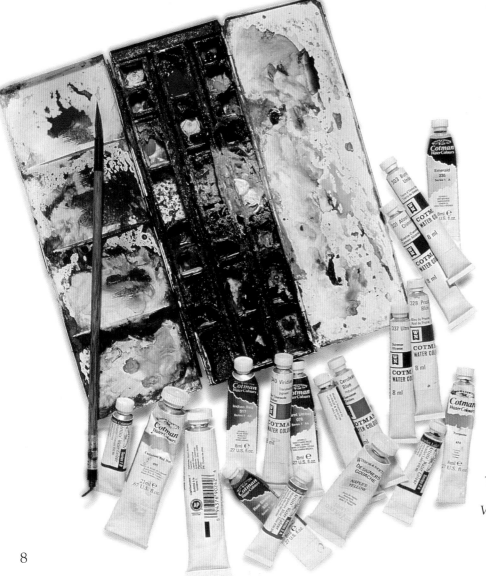

There is order in this chaos. I keep full pans for the colours I use most and half pans for the others. There are also a few empty slots for any new colours I might choose. Very occasionally I take all the pans out and give the tin a good clean.

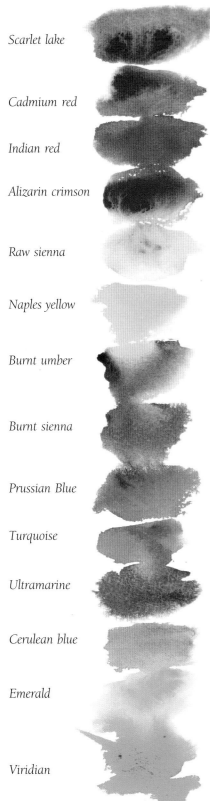

Scarlet lake

Cadmium red

Indian red

Alizarin crimson

Raw sienna

Naples yellow

Burnt umber

Burnt sienna

Prussian Blue

Turquoise

Ultramarine

Cerulean blue

Emerald

Viridian

Chinese white

which is supposed to contain brushes, is now also filled with colours. I have space for twenty-two colours in my tin: the fifteen colours shown left, which are my standard set; a pan of ox gall; and any special colours I may add from time to time. The tray is divided into areas of colour, reds in one area and blues in the other.

Paints can be bought in pans or tubes. Although I started with a tin full of pans, I now buy tubes of paint to top up the pans as they become depleted. This way, I frequently recharge the colours and I am always using fresh clean paint. I can also experiment with different ranges of paints.

Brushes

While travelling in the Far East, I developed a preference for Chinese-style brushes and I tend to use these for all my paintings. However, the watercolour brushes available from local art shops are very good. As a general rule, I would advise that you buy brushes that are larger than you think you need. A large round brush still comes to a fine point, so you can use it for all types of work. Small brushes can be very restricting in their use, and they cannot hold large amounts of paint.

A large round or flat brush (depending on your preference) is needed for laying washes. If you need to economise, a small household paint brush will work quite well. I normally use a No. 14 round brush or a 25mm (1in) flat brush.

I would suggest you buy two No. 6 round brushes for general use. Keep one for painting and the other for softening edges with clear water.

A small round brush (No. 2 or 3) is handy for touching in fine detail, and a long-haired rigger brush is perfect for long thin strokes.

A small stiff-bristled oil painting brush can prove a useful addition to your kit.

Never throw any brushes away. When they become useless for general painting, you can still use them for the split-brush technique and for applying masking fluid.

Paper

There are many types of watercolour papers and each has its own characteristics. The only way you can find out which type suits you is to obtain examples and test them. If you can get manufacturers' samples, this will be a great help.

Paper is grouped into three categories of surface: Hot pressed, Not, and Rough. Hot pressed has a smooth surface that is good for detailed work. However it has a limited use with the textural effects of dragging and dry-brush work. Not has a textured surface and is the most popular surface to work on. The texture allows you to use all the different effects, and still add detail. Rough has a heavily textured surface, and is most effective with a broad painting technique. A brush whipped across this paper leaves a scattering of dots on the rough surface – very effective in the right hands.

All three surfaces are available in different thicknesses (weights), the heaviest being the most expensive. Lightweight papers, 190gsm (90lb) and below need stretching before painting. Thicker paper, say 300gsm (140lb), need not be stretched.

My favourite paper is 190gsm (90lb) Not. Its texture allows me to be creative in my painting techniques, and it is strong enough to withstand the scrubbing and scratching techniques that I use.

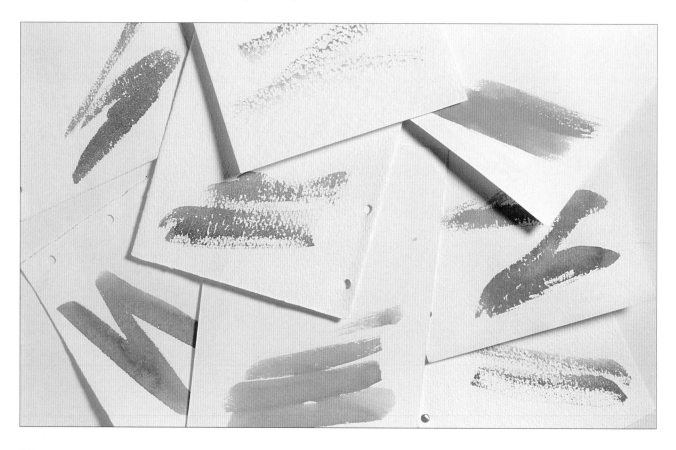

Other equipment

Painting boards These can be plywood, blockboard or MDF. If you make yourself two or three boards, you will always have a stretched surface available to paint on.

Water container Jam jars or old margarine containers make adequate water containers. Whatever you use, do choose something with a large flat base so that it cannot be knocked over too easily. I use a collapsible container that I found on a visit to China.

Pencil I use a soft 2B pencil for sketching. You could use a B or HB, but harder leads can scratch the paper and leave unsightly marks.

Eraser Use a soft eraser to remove pencil lines, and to create highlights on a painted surface.

Penknife or craft knife For sharpening pencils and cutting the finished painting from the painting board. It can also be used for the scratching-out technique.

Paper tissue This is ideal for cleaning your palette and for removing excess water from the brush. It can also be used for dabbing the painted surface to lift out unwanted colour.

Hairdryer Use this to speed up the drying process, but watch out for the formation of hard edges.

Sponge I use this for lifting out paint, and it is very helpful for creating large highlights.

Razor blade For scratching out fine lines such as blades of grass and twigs. It can also be used in conjunction with an eraser to create highlights.

Candle For rubbing a wax resist on the paper prior to painting. The wax causes the paint to bead up and develop textural effects.

Ox gall This is a wetting agent that can be used in washes to help colours flow more freely. I also use it to add highlights and unusual effects in washes – dabbed into the surface of a wet wash it will cause the colours to disperse from the point of application. It can be purchased in liquid or solid form.

Masking fluid I use this with an old brush for masking out intricate areas that would be hard to paint around.

Salt Sprinkle salt on wet paint to create abstract patterns and textures. You can use any type of salt, but normal table salt works very well.

I like to work on a flat painting surface, with the painting board resting on my knees or, when in the studio, on a work surface. When applying washes, I prop up one end of the board to create a slight incline to encourage the colours to flow across the paper.

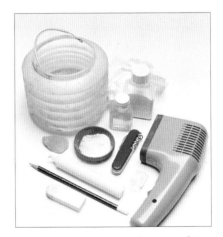

Water container, paper tissue, masking fluid, liquid ox gall, sponge, salt, penknife, hairdryer, soft eraser, 2B pencil, candle, razor blade.

Techniques

In this chapter, I introduce some of the techniques that I use in my paintings. Apart from the essentials – washes, dry-brush work and wet in wet – the other techniques should be used selectively to create particular effects.

Watercolour washes

Laying a flat even colour is quite easy, provided that you prepare for it. Mix enough colour to complete the job. Angle the painting slightly upwards to allow the wash to run downhill. Fully charge a large brush, then run the brush across the top of the paper; the paint will bead along the full length of the bottom edge of this stroke. Recharge the brush and, picking up the bead of colour, work another stroke. Work down the painting, charging the brush at each stroke. Use the tip of a dry brush or paper tissue to remove the bead below the last stroke (an ugly hard edge may form if you leave this to dry).

Make a graded wash by diluting the colour with water on each stroke, or a blended wash by gradually introducing another colour. You can also lay one wash over another, but make sure the first wash is completely dry, otherwise it will begin to lift.

To achieve a really soft edge to a graded wash, such as this example, use clear water for the final stroke.

Some pigments are granular. If you tip the painting back and forth while the paint dries, the fine grains of colour fall into the recesses of the paper and create a rather coarse textured wash (above top). To avoid this and achieve a really smooth wash (above), turn the painting over and allow it to dry face down.

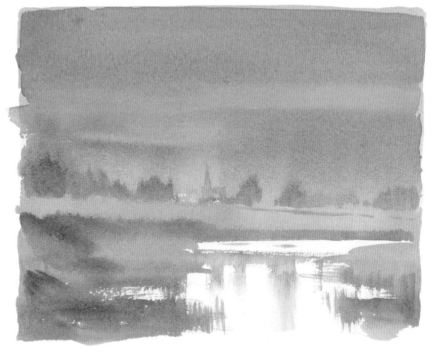

In this landscape, the blue wash of the sky was allowed to run into that of the foreground meadow. Only a few more strokes were necessary to complete the picture.

Skies

Painting skies gives you the opportunity to be really inventive. Take time to look at skies, and make notes about formations that could work well in a painting. Late afternoons and early mornings provide the most atmospheric effects.

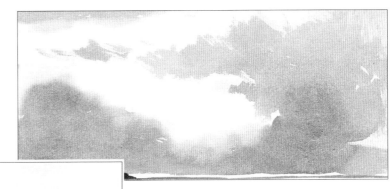

A first light wash of raw sienna was allowed to dry, then a second wash of ultramarine mixed with a little burnt sienna was brushed on vigorously. I used a brush loaded with clear water to soften the top edges of some of the clouds

Cerulean blue and a speck of alizarin crimson formed the first wash of this sky. I then brushed over this with ultramarine and a little burnt sienna. Again the top edges of the clouds were softened with a brush loaded with clear water.

Here, raw sienna was laid as a flat, smooth wash. Then, while this was still wet, a mix of cerulean blue with a touch of alizarin crimson was applied to make the delicate grey wash of the clouds. I tipped up the bottom of the painting to encourage the colours to drift upward.

A blended wash of cadmium orange and ultramarine was allowed to dry. The clouds, in ultramarine and burnt sienna, were added using a dry brush.

I laid a first wash of Indian red and cerulean blue, leaving highlights in the centre. While this wash was still wet, I added Winsor blue and Indian red to form the clouds.

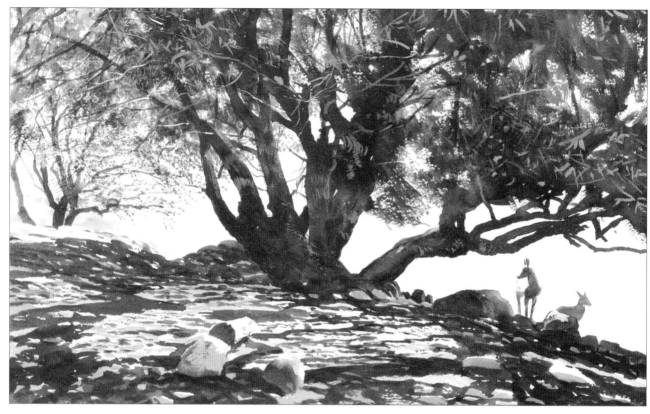

In this scene, dry-brush work has been used extensively to render the ragged canopy of shade under the large tree.

Dry-brush work

For this technique you need to use as little water as possible. The paint sits on the textured surface of the paper (rather than soaking into it) to leave speckles of white paper amidst the brush strokes. There is a fine line between not having enough water in the brush and too much, so experiment with the technique on a piece of scrap paper.

Dry-brush work is very hard on brushes – they have to be pressed firmly on to the paper – so select an old brush that has lost its point.

Load a brush with colour, then soak up excess water, without removing the paint, by touching a paper tissue against the hairs of the brush where they meet the ferrule.

The paint breaks up as the brush is dragged across the surface of the paper. These marks could be the speckled highlights on a river.

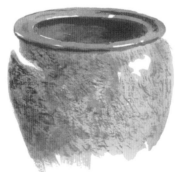

Dry-brush work was used to create the rugged surface of this pot.

Here, random scrubbing of colour gives the texture of grassy undergrowth.

Wet in wet

This is such a useful technique, and it typifies the very essence of what we think of as watercolour. It can be used broadly, where the whole surface of the paper is brushed with water prior to painting, or in small areas of detail.

When paint is applied to a wet surface it spreads out in a soft blush of colour. Other colours can be added and these blend naturally on the paper. Start experimenting, and you will find endless possibilities.

However, there is one ever-present danger; the formation of hard edges. When there is a lot of water on the paper, some parts of the paper will dry more quickly than others and the areas between dry and wet can turn into ugly lines. To prevent hard edges occurring, avoid having too much water on the paper and watch the drying process, so that you can make adjustments before it is too late.

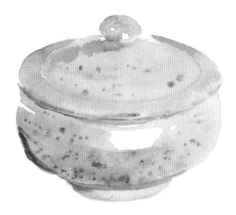

All the colours on this pot were added wet in wet. The base colour is cerulean blue, and into this I brushed emerald and a little alizarin crimson. The rusty spots are touches of burnt sienna.

Paint applied to a wet surface feathers out softly.

Below
This sky was formed naturally by dropping colours into the wet background of raw sienna. The same colours are echoed below in the river. The irregular line of the clouds was created as the paint dried.

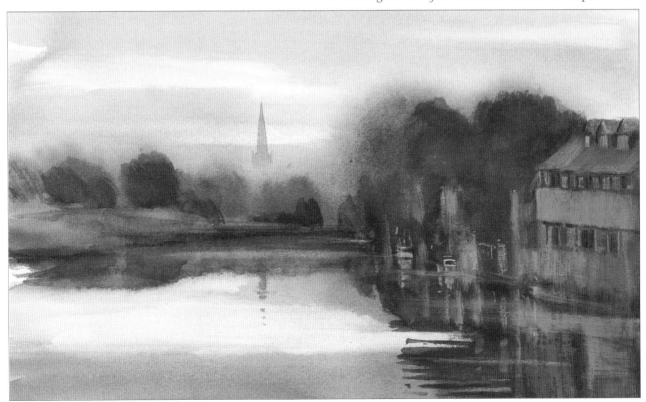

Other techniques

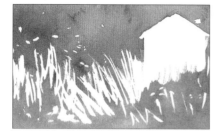

Masking fluid This is very effective for masking out intricate areas that would be hard to paint around, especially when applying a wash, where speed is essential. To remove it, simply rub it away with a soft eraser.

Scratching out This technique is useful for creating the fine lines of a tangle of undergrowth, or for graining a piece of wood. Wait until the paint is nearly dry and then scratch out the lines with a sharp penknife or razor blade.

Wax resist When a candle is rubbed on the paper, it forms a resist that causes the paint to bead. It is useful for creating textured areas on rocks or tree bark. An effective but unpredictable technique.

Ox gall This is a wetting agent that helps washes run more smoothly. I find it useful for painting wet-in-wet effects; the paint tends to flow away from the point of application and create unusual patterns.

Salt Salt sprinkled over a wet surface can have a spectacular effect. As the salt dissolves, a speckle of white dots develop. Its effects are rather unpredictable, and are best used in free-flowing, imaginative washes.

Cutting out Very effective for creating fine white highlights. I use it in river scenes where a fine shaft of light cuts across the water. Cut two lines close together, then carefully scratch away the strip between the cuts.

Rubbing out A useful way of adding gentle highlights. Simply rub away with an eraser. I often use it against the edge of a ruler to give a straight line of highlight.

Dabbing Dark areas of colour can be made more interesting by dabbing them with a sponge or paper tissue. However, take care not to create a muddy mix.

Split brush This technique is very useful for developing foliage. Press a brush into the palette to splay out its bristles, then dab the paint on to the paper.

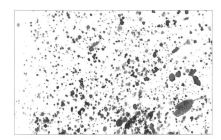

Spattering Tap a loaded brush against a finger so that a spatter of fine dots of paint fall on the paper. Cover the area you do not want spattered, as the dots of paint can travel a long way. Alternatively, use the technique with masking fluid to create speckled highlights.

Sponging The sponge can be an all purpose tool. Some artists use it a lot for painting cloud effects. I use it mostly for lifting out large areas of paint, especially for big soft-edged highlights on water.

Imprinting Paint can be picked up and transferred to the painting by way of dabbing with a sponge or tissue to add textural qualities.

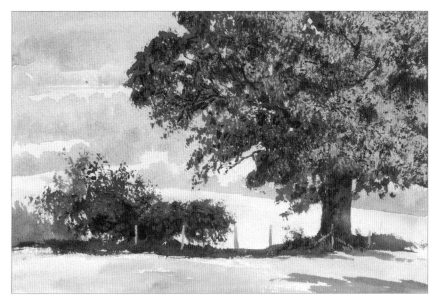

Overpainting This technique (using opaque colours) must be applied sensitively to work well – if opaque colours are worked indiscriminately, the wonderful quality of watercolour will be lost. I use two opaque colours, Naples yellow and Chinese white, which I mix with the transparent colours to give me any colour or shade I require. Overpainting is very useful for areas of foliage and grass, where the delicate tapestry of leaves can be suggested by stippling with a fine brush. For larger areas, overpainting with the split-brush technique can be very effective.

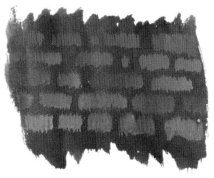

A little overpainting can work wonders with brickwork.

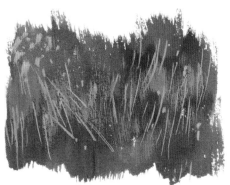

The quality of foliage can be built up using the split-brush technique.

17

Using colours

Although there is a large selection of watercolours available, I would suggest you start with a basic, pre-selected set of colours. As you gain experience, you can adapt your palette to suit your taste of subjects.

Many artists find they turn to a small number of colours repeatedly and I am no exception. My particular favourites are burnt sienna, raw umber, burnt umber, ultramarine and viridian, and they seem to crop up in every one of my paintings.

Burnt sienna is a rusty orange which, when mixed with other colours, always gives me the range of warm tones I seek. It is the perfect colour for rusty machinery.

Raw sienna is my favourite yellow. I mix it with ultramarine to create subdued greens, and with burnt sienna to create a rich mix of golden hues.

Burnt umber gives me my dark tones. I mix it with viridian for dark areas of foliage. When added to Prussian blue, it is the nearest I get to black.

Ultramarine is my all-purpose blue and is probably the colour I use most, from skies to ploughed fields.

Viridian is a great green. I like painting trees, and I especially love the deep greens one sees in late summer. Painting large areas of foliage can be a challenge, particularly the dark tones which can easily become dull and flat. I find that mixing viridian with blues and browns gives me just the right quality of tone.

Rather than include the usual colour mixing wheel, I have annotated the painting opposite to illustrate some of the colour mixes and the more interesting techniques used to paint it.

Most of the individual scales on the dragon's body are drawn with a mix of burnt sienna and ultramarine. However, I picked out some of the larger scales, lower down the body, using viridian and sap green mixed with burnt sienna.

The effect of salt is unpredictable. It breaks up the background wash and makes it more lively. Compare the resultant effect here with the more gentle speckles at the top-right part of the painting.

I blended Prussian blue into a wash of cerulean blue to create a background graded from dark to light blue.

This area of speckled white dots was created by flicking masking fluid on to the paper before applying colour.

Chinese Dragon
535 x 335mm (21 x 13¼in)

This painting required a lively use of colours to add to the dramatic outline of the dragon, which also needed to be offset against a soft background. However, rather than lay in a simple wash, I made the background more interesting by first flicking spots of masking fluid on to the paper and subsequently sprinkling salt on to the wet washes. The two blues used for the background are very different. Prussian blue is a hard, dark blue that I would normally not use for skies, whereas cerulean blue is a soft sky blue. Mix cerulean blue with other colours to make subtle shades of grey.

Masking fluid painted over detailed areas such as the head of the dragon enabled me to paint in the background of cerulean blue briskly and freely.

Cerulean blue

To create the soft, rounded shape of the dragon's body, I first painted the light side with clear water. I then applied dark colours to the underside of the body and allowed them to disperse into the wet white areas.

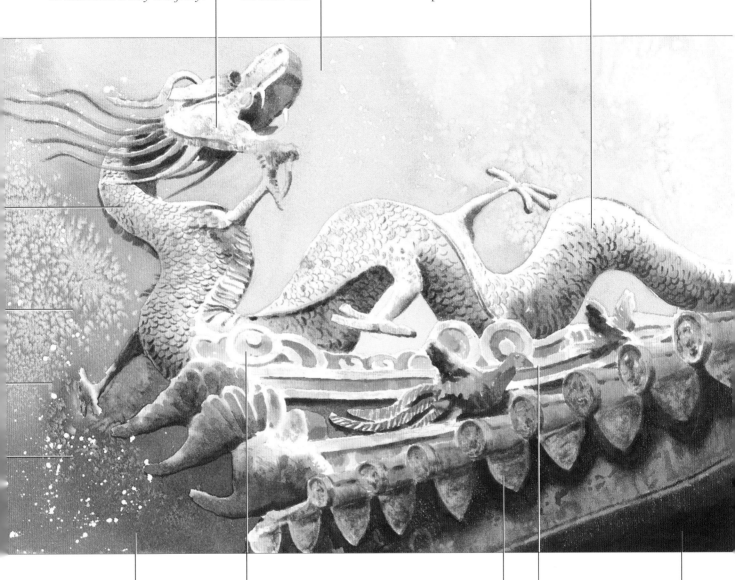

Prussian blue

Scarlet lake

I used burnt sienna, cadmium red and ultramarine to suggest detail. The edges of shadows are softened with a brush loaded with clear water. When the initial colours are dry, I added the detail of weather-worn paintwork using a mix of emerald and Chinese white.

For really dark colours I use Prussian blue and Indian red, or Prussian blue and burnt umber. Black is not in my paint palette.

Gamboge

19

Irises

Flower studies provide the opportunity to experiment. I like to focus on one or two flower heads, and depict them in detail against a soft, contrasting background. I chose irises for this first demonstration because they are a particular favourite of mine. They are very sculptural, and the strong, bold outlines of their petals and foliage work very well against a soft, seemingly out-of-focus background.

Before starting to work on the background, I apply masking fluid to all the foreground detail. This allows me to work loosely and quickly over the whole area of the paper. I use the wet-in-wet technique to work splashes of colour into the background, allowing the colours to blend together on the paper. I then add salt to the wet colours to create other interesting effects.

The most important factor about flowers is their freshness, so do not overwork the colours or techniques.

<table>
<tr><td>You will need</td></tr>
<tr><td>190gsm (90lb) Not paper stretched on a board</td></tr>
<tr><td>2B pencil</td></tr>
<tr><td>Masking fluid and an old brush</td></tr>
<tr><td>Cerulean blue, Prussian blue, alizarin crimson, gamboge, cadmium orange, viridian, ultramarine, burnt sienna, dioxazine violet</td></tr>
<tr><td>Nos. 6 and 14 round brushes</td></tr>
<tr><td>Table salt</td></tr>
<tr><td>Razor blade and an eraser.</td></tr>
</table>

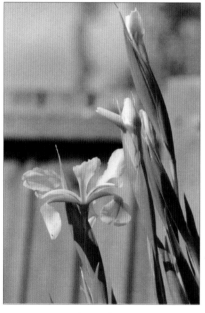

You can paint from photographs of blooms that will not be around for long, but it can be very pleasant sitting in the garden working from life.

1. Use masking fluid and an old brush to outline all the flower petals, stems and leaves. Flick spots of masking fluid randomly over the background area.

2. Use a No. 14 round brush and clear water to wet parts of the background area.

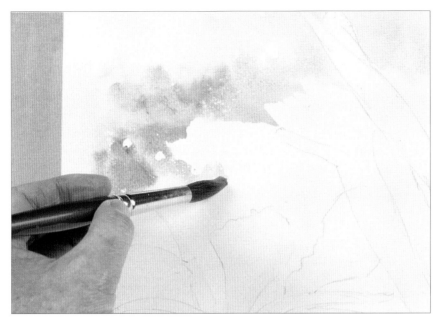

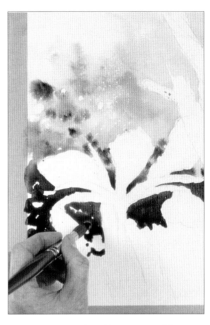

3. Mix a wash of cerulean blue, then paint this randomly across the top part of the background.

4. Mix a wash of Prussian blue with a touch of alizarin crimson, then paint this across the middle parts of the background.

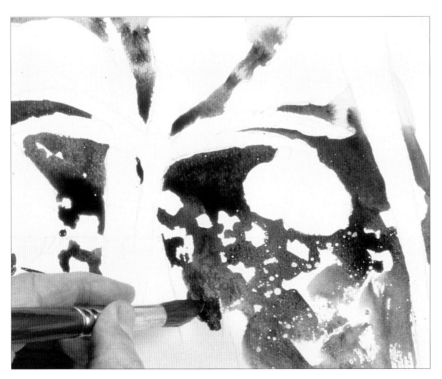

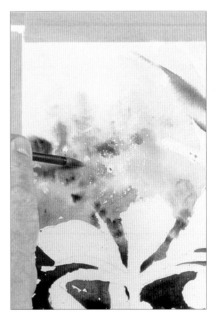

5. Add more alizarin crimson to the wash as you near the bottom of the painting.

6. Dilute the wash, then use a No. 6 round brush to lay in a spike of foliage, wet in wet. Splatter spots of cadmium orange, wet-into-wet, randomly over the background colours.

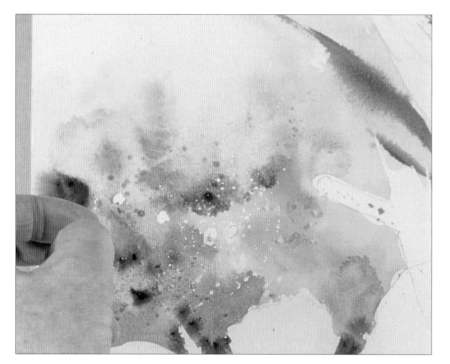

Salt will continue to work while the paint is wet. You can stop the effect at any time by drying it with a hairdryer.

7. Sprinkle salt randomly over the wet paint. The effect starts almost immediately and will continue to develop all the while the paint is wet.

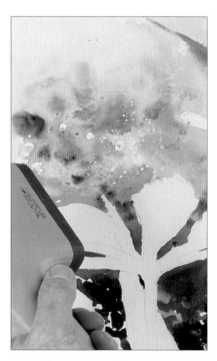

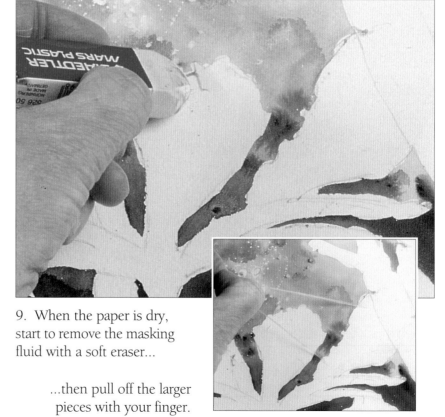

8. When you are happy with the salt effect, dry the painting with a hairdryer – watch out for unwanted hard edges forming.

9. When the paper is dry, start to remove the masking fluid with a soft eraser...

...then pull off the larger pieces with your finger.

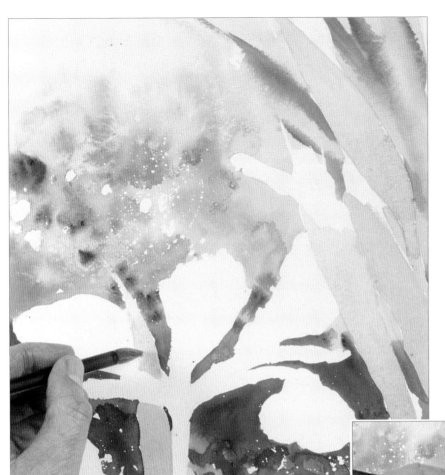

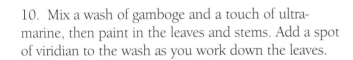

My wash of gamboge, ultramarine and viridian still shows traces of the individual colours.

10. Mix a wash of gamboge and a touch of ultramarine, then paint in the leaves and stems. Add a spot of viridian to the wash as you work down the leaves.

11. Add more ultramarine to the wash and start to develop the tone and shape of the foliage. Use the tip of the brush to define the edges of the foliage. At this stage, take care not to overwork the picture, much of its charm relies on the speed and handling of the paint.

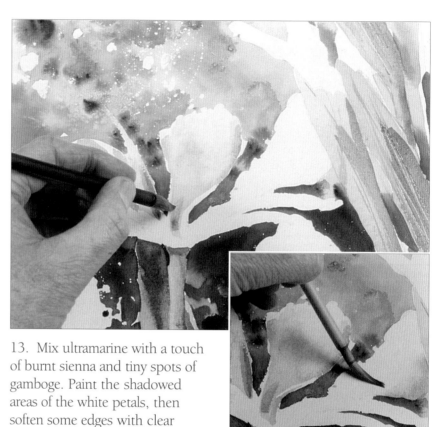

12. Leave the paint to dry slightly, then use the end of a razor blade to scratch fine lines into the dark colours and reveal the paler tones beneath.

13. Mix ultramarine with a touch of burnt sienna and tiny spots of gamboge. Paint the shadowed areas of the white petals, then soften some edges with clear water to make them merge into the white of the paper.

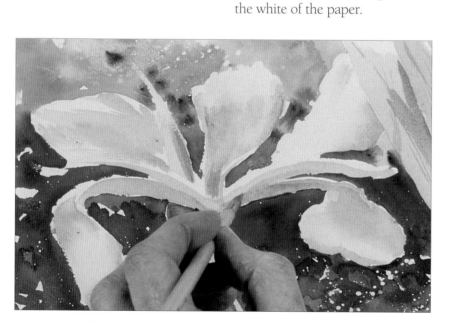

14. Use gamboge and a small round brush to start building up colour on the petals. Soften each area with clear water. Add some shadows using a wash of ultramarine and viridian.

15. Mix dioxazine violet with touches of ultramarine and gamboge, then add tone and shape to the hues.

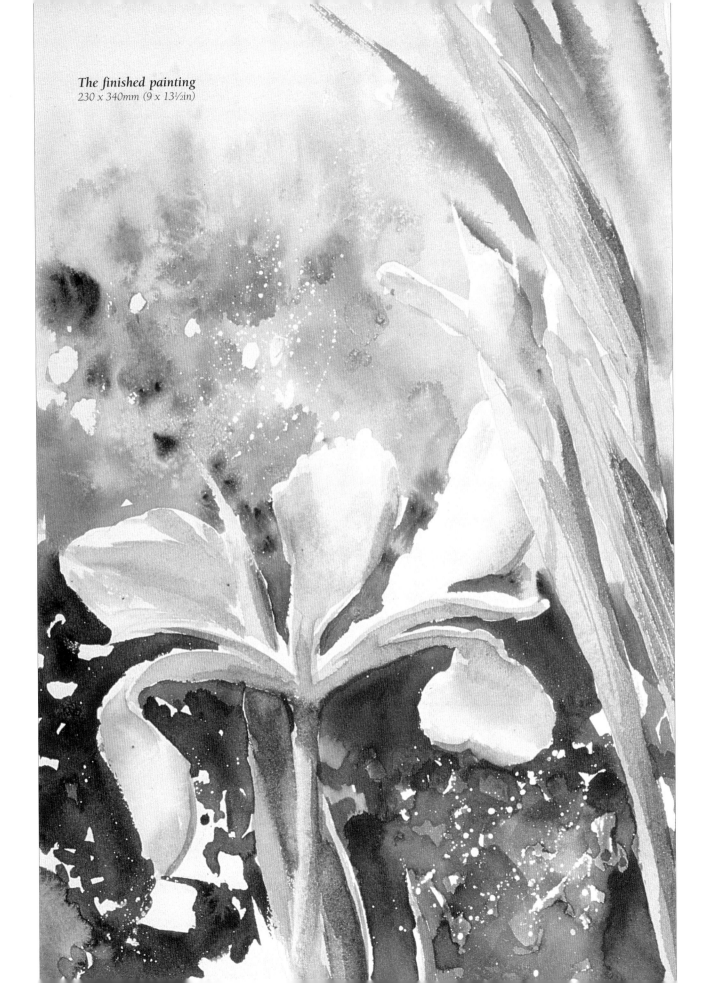

The finished painting
230 x 340mm (9 x 13½in)

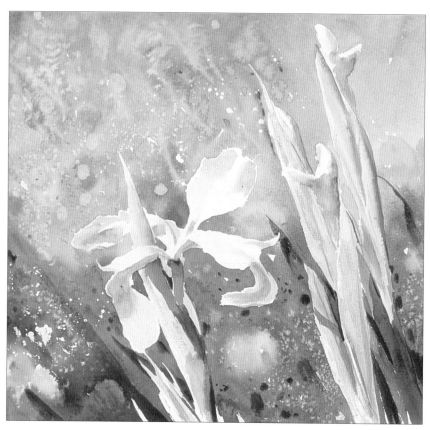

Irises
340 x 325mm (13½ x 12½in)

This painting is a variation of the demonstration on pages 20–25.

Again, I used masking fluid to mask out the foreground detail while I worked on the background. I wetted the paper with clear water, then applied very fluid mixes of cerulean blue and Prussian blue. I dropped gamboge, wet in wet, on to the surface and allowed this to spread out into the blues. A brush charged with ox gall was dragged over the surface and salt scattered into the wet paint to add interest and textures.

The white of the flower petals works well against the darker background and only a little shading of ultramarine, with a touch of burnt sienna, was needed to complete the picture.

Poppies
340 x 260mm (13½ x 10¼in)

The colour of these flowerheads needs to be bright and vibrant, so I used scarlet lake, which retains its brightness when dry. The whole painting was executed with speed and energy to give it a lively, spontaneous quality.

Masking fluid was used extensively to create the many highlights on the flowerheads and background details. These flashes of white paper are crucial and really bring this painting to life.

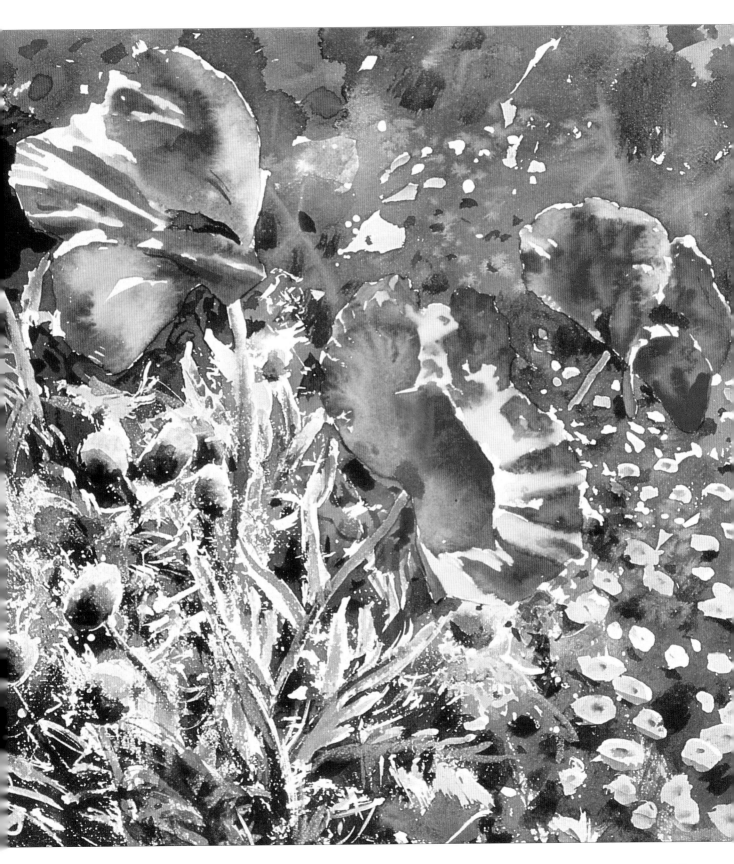

Chub Stream

Living next to a river has given me a lot of experience in painting water. I like painting water scenes on warm summer evenings, before the sun goes down, when its golden hues spread across the water and mix with the deep shadows of the trees on the river bank. But then, I also enjoy winter scenes, and the challenge of trying to capture the shades of grey of the ice as it spreads across the surface.

The subject for this demonstration is a little stream overhung by a large tree that creates an attractive arch. The one problem presented by this scene is the depth of tone – the foliage is very dark – and there is a danger of overworking the paint and creating a dull image. To avoid this, I work quickly and I repeatedly return to the palette to make fresh colour mixes. Later, I define the foliage in more detail by overpainting a variety of other colours.

The depth of tone of the foliage is repeated in the reflections in the stream, but here the challenge is to create the impression of movement by depicting the ripples in the water.

You will need

190gsm (90lb) Not paper stretched on a board

2B pencil

Masking fluid and an old brush

Cerulean blue, ultramarine, raw sienna, burnt sienna, viridian, cadmium orange, burnt umber, alizarin crimson, Indian red, Naples yellow, Chinese white

No. 6 round brush, an old split brush and a small, stiff oil-painting brush

Razor blade and an eraser

Paper tissue.

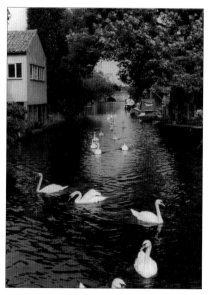

In this reference photograph, it is difficult to make out the distant bridge. The bridge is the focal point of this scene, so I purposely painted it more clearly and made its arches more visible.

1. Sketch in the outlines of the main elements of the scene. Use masking fluid and an old brush to mask all the swans. Mix a wash of cerulean blue with a touch of burnt sienna, then use a No. 6 round brush to paint the sky.

28

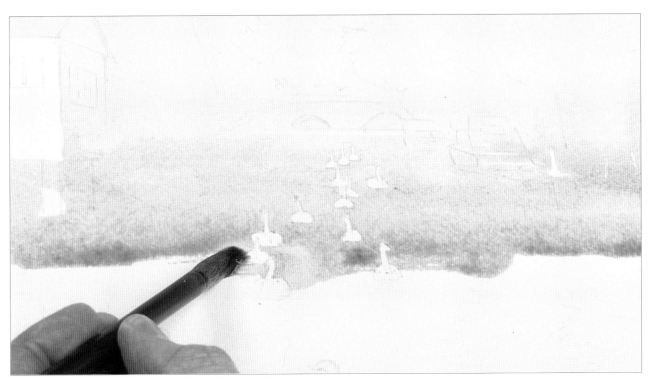

2. Mix ultramarine with a touch of burnt sienna, then wash in the foreground water, blending it with the still-damp colour of the sky. Paint around the highlighted areas of the boat.

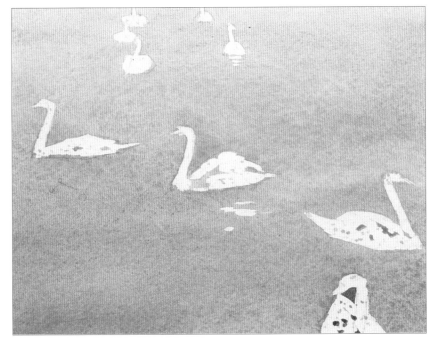

3. Work down to the bottom of the painting, gradually increasing the intensity of colour. Note the effect of granulation (above). If you like this effect, leave the painting to dry face up. However, if you do not want a granular effect, turn the painting board upside-down and dry the painting, face down (right). Note how the granulation has been reduced.

Never throw old brushes away. They are very good for the split-brush technique

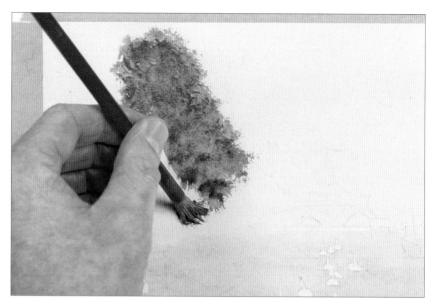

4. Mix raw sienna and ultramarine with a touch of burnt sienna, then use an old brush and the split-brush technique to develop the foliage. Add a tiny touch of viridian to vary the tone. A word of warning about viridian – use too much and the painting will look 'chocolate boxy'.

5. Use a weak wash of ultramarine and a No. 6 round brush to paint in the distant trees behind the bridge. Soften the top of these trees and the bottom of the fir tree with clear water.

When mixing colours in my palette, I like to have lots of tones available around the edge of the mix. This picture shows the mix of greens used to paint the foliage in step 6.

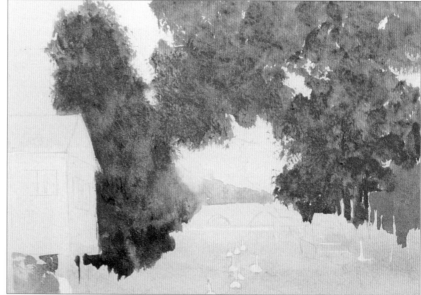

6. Add more raw sienna to the wash and develop the large tree (centre and right of the painting). Vary the tone to create shape and form. Go back over the foliage with darker tones to create the texture of leaves in the foliage. Use burnt sienna to develop shadows under the right-hand trees and below the house.

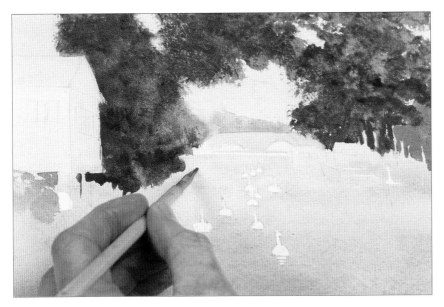

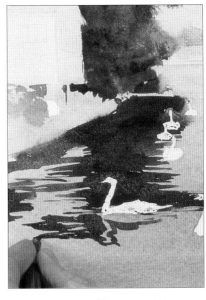

7. Use a mix of Naples yellow and alizarin crimson to define the bridge. Vary the tones with touches of Chinese white to create texture. Use the Naples yellow and alizarin crimson mix to wash in reflections of the bridge, leaving a highlight between the bridge and its reflection.

8. Use a mix of burnt umber, ultramarine and a touch of Indian red to paint the reflections of the trees.

9. Use the same mix to block in the dark arches under the bridge. Continue to build up reflections using the washes in the palette.

10. Add a touch of raw sienna to a wash of burnt sienna, then paint the brickwork of the wall on the bank of the river. Dilute the wash slightly, then work the reflections in the water.

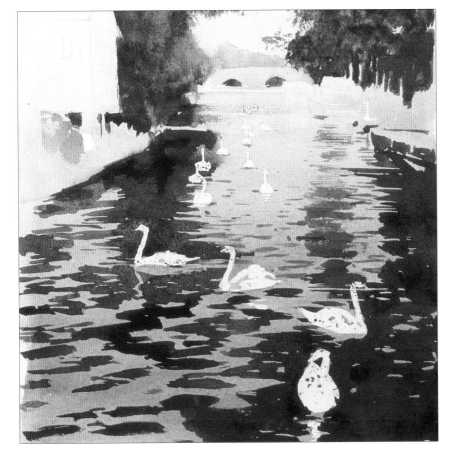

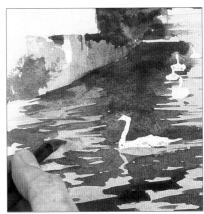

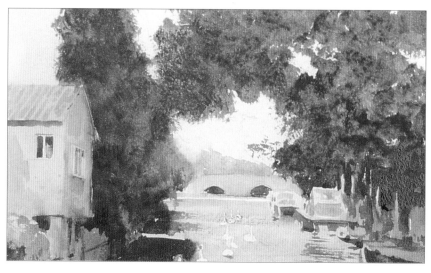

11. Use a wash of alizarin crimson, Naples yellow and ultramarine to paint the gable end of the house. Dilute the wash, add more Naples yellow, then paint the side of the house. Add more alizarin crimson and ultramarine, then paint the roof. Leave to dry.

12. Mix a weak wash of ultramarine and lay this over the gable end of the house. Add a touch of burnt umber and paint in shadows and windows. Remember to leave highlights. Use the same mix to develop the boat. Use all the colours to define shape in the building and bridge.

13. Use a razor blade to scratch a highlight across the water, then go over the area with an eraser.

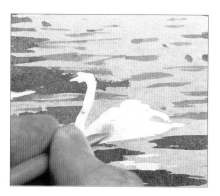

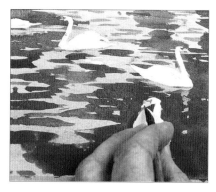

14. Remove the masking fluid from the swans. If colour has penetrated on to the masked area, use a stiff oil-painting brush and clear water to scrub out the colour. Dab off excess moisture with paper tissue.

15. Mix a weak wash of cadmium orange, then paint the middle distant and foreground swans and their reflections. Use ultramarine and alizarin crimson for shadows on all swans. Paint the beaks with cadmium orange.

Opposite
The finished painting
230 x 340mm (9 x 13½in)
I went back over the whole painting, adding points of interest: the suggestion of tiles on the roof; more texture on the walls; and some detail on the distant swans. I overpainted highlights on the foliage using the split-brush technique and a mix of Naples yellow with touches of viridian and Chinese white. I also developed the reflections to create more movement in the water.

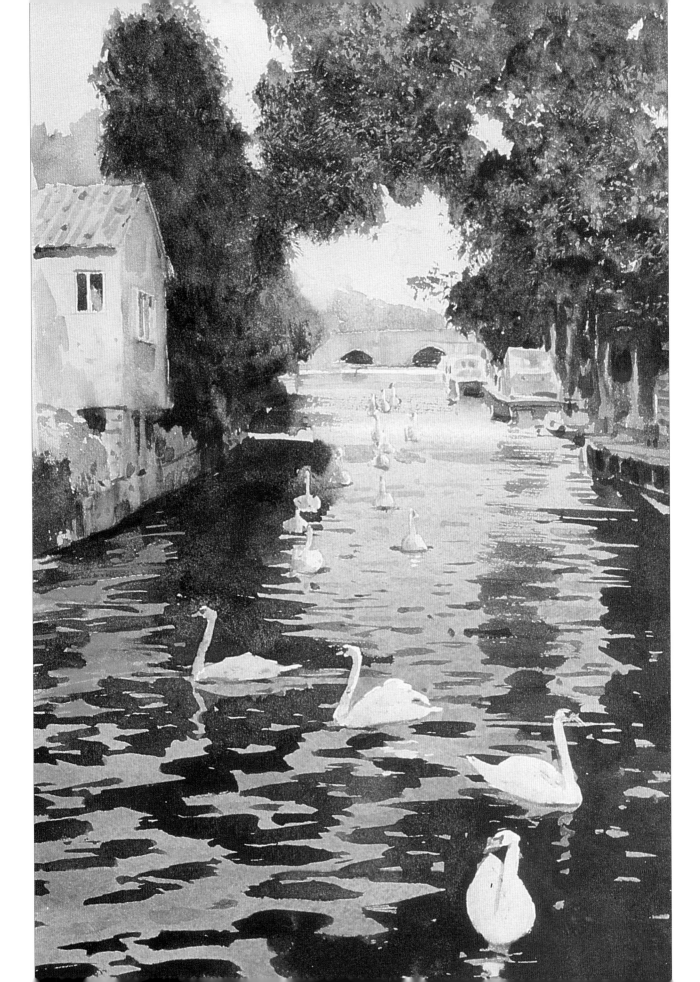

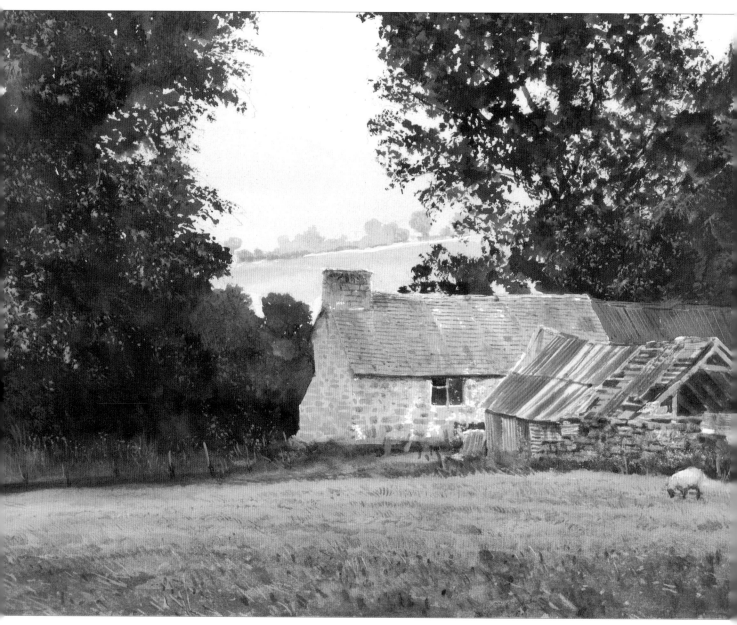

Farm House

350 x 265mm (13¾ x 10½in)

The split-brush technique is ideal for painting the dark backdrop of foliage in this painting, and for creating its ragged-edged silhouette against the sky.

I rubbed a little candle wax on the areas of stonework, then brushed over this with ultramarine and a little burnt sienna to create a speckled texture.

Rooftops can be quite difficult to paint convincingly. Do not try to paint every single tile; patches of detail here and there are all you need – the eye tends to fill in the rest. Burnt sienna is the perfect colour for rusty iron sheeting, but here I added a little yellow to lighten some areas, and red to provide richer colours in others.

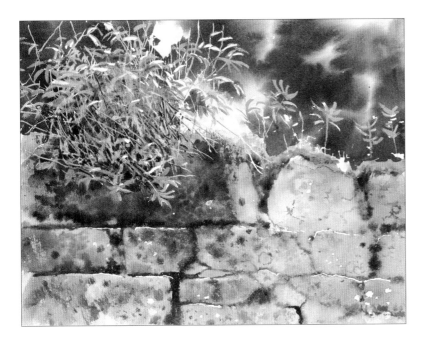

Stone Wall
325 x 250mm (12½ x 10in)

I started this painting by rubbing candle wax over areas of the stonework, and by applying masking fluid to individual stones where the light catches the edge of them.

The colours, ultramarine, Naples yellow and burnt sienna, were applied to a background wetted with clear water. While the paint was still wet, the dark gaps between the stones were added, and the paint was allowed to mix with the background colours.

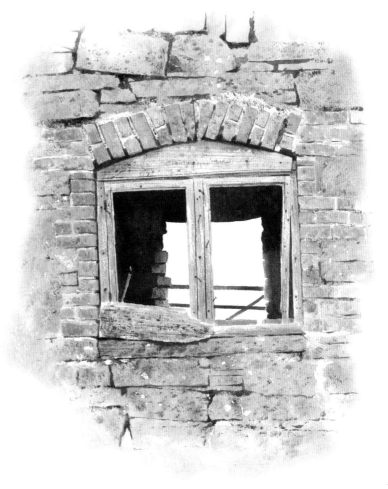

Empty Window
220 x 290mm (8¾ x 11½in)

Windows and doors provide excellent subjects to paint, and their geometric shapes blend well against irregular stonework.

To make this subject work as a painting, I softened the outer edges with clear water. The resultant vignette helps the composition by drawing the eye to the centre of the painting. I try not to overload this type of painting with detail, and I allow colours and textures to mix naturally on the paper.

35

Mother Hen

500 x 330mm (20 x 13in)

Different textural effects should be used sensitively to work well.

In this farmyard scene, I used the scratching out technique to create detail on the hen's feathers, and to develop the graining of the wooden planks behind.

In the foreground, a little overpainting helps describe the ground litter.

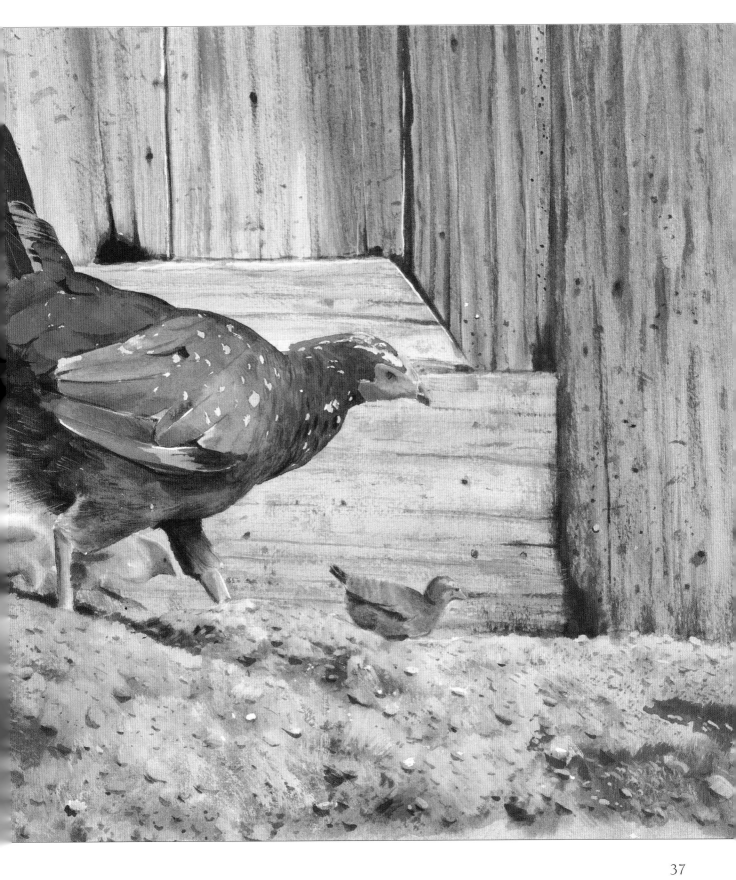

Country Lane

This cottage on the brow of a hill makes a good composition – the eye is drawn to the centre of the scene by the converging lines of the hedge and the tall roadside bank. The outline of the cottage and the delicate brush work of the surrounding trees are important to the composition, so I avoid painting a complicated sky.

I use candle wax to add texture to the rendering on the cottage and the foreground surface of the lane. I also use ox gall to give the impression of tyre tracks on the lane. These techniques are somewhat inexact but, whilst it can be difficult to judge how they will work, they are both worth trying. However, if you feel that the painting does not benefit from them, you can always brush them out with clear water and rework the area in other ways.

You will need

190gsm (90lb) Not paper stretched on a board

2B pencil

White candle

Ultramarine, raw sienna, burnt sienna, viridian, burnt umber, alizarin crimson, Indian red, Naples yellow

Ox gall

No. 6 round brush and a small rigger brush

Paper tissue.

The telegraph pole does nothing for this composition, so I left it out of the finished painting.

1. Use the 2B pencil to sketch in the main elements of the landscape, then make random marks with the white candle over the gable end of the cottage and on either side of the lane.

2. Use a No. 6 round brush and a wash of Naples yellow with a touch of alizarin crimson to paint across the sky area. Leave to dry.

3. Now lay a wash of ultramarine over parts of the yellow sky. Use a No. 6 round brush and clear water to soften the edges, and to move the ultramarine around. Add more ultramarine, then darken the right-hand side of the sky.

4. Mix a strong wash of burnt sienna, raw sienna and ultramarine, then block in the right-hand hedge. Add burnt umber to develop the foliage. Soften the top of the hedge with clear water. Add Naples yellow to the wash, then use this to soften the bottom of the hedge and to paint the grass bank. Add touches of ultramarine to create shape and form.

5. Add viridian to the mix then paint texture into the grass bank.

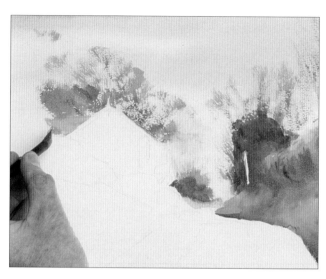

6. Mix burnt umber and viridian to paint more texture on the bank and hedge. Then, using a mix of burnt sienna and ultramarine and the dry-brush technique, suggest the twigs against the sky.

7. Use the same colour mix to dry brush the foliage behind the cottage. Soften some images with clear water and a large brush. Then use touches of ultramarine to block in the roof of the cottage.

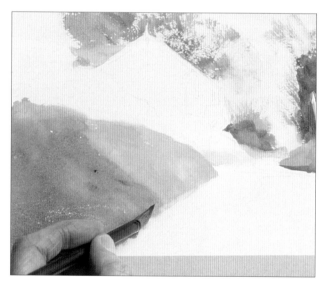

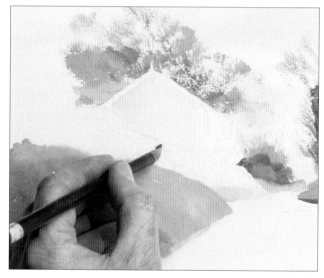

8. Use various mixes of Naples yellow, burnt sienna and ultramarine to wash in the left-hand grass bank and then to develop its texture.

9. Mix alizarin crimson and Naples yellow, then block in the gable end of the cottage. Note the hint of texture created by the wax resist.

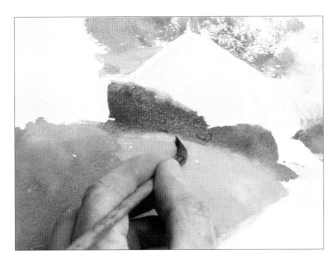

10. Use a mix of burnt sienna and ultramarine to develop the hedge in front of the cottage. Soften the edge where the hedge meets the grass bank. Leave to dry. Use the mixes in the palette and the dry-brush technique to develop the grass bank.

11. Mix Indian red, burnt umber and ultramarine with the minimum of water. Load the brush, remove excess paint with a paper tissue, then use the side of the brush to scrub the paint on to the foliage at the left-hand side of the painting.

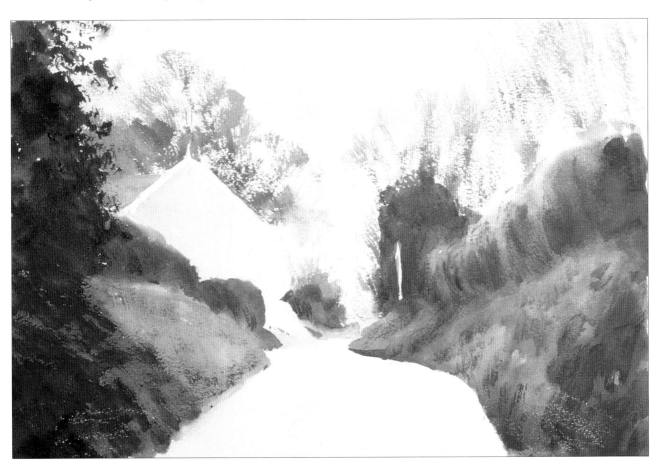

12. Develop the shape and tone of the foliage using all the colours in the palette.

13. Use ultramarine, dirtied slightly in the palette, to paint over the gable end of the cottage. Now the wax resist shows its true value. Use the same colour to apply tone to the front of the cottage.

14. Use a mix of burnt sienna and ultramarine to paint shadows under the eaves and at the side of the drainpipe. Start to define the entrance porch. Use touches of previous mixes in the palette to start painting detail. Tone down the white highlights. Wash burnt sienna over the gable end.

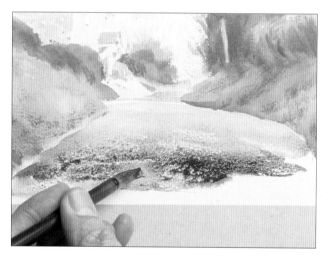

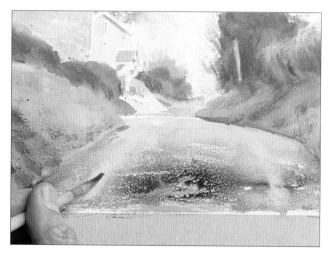

15. Make a mix of ultramarine and burnt sienna, then, leaving a white highlight at the top of the hill, start to block in the lane (note the texture created by the wax resist applied in step1). Darken the mix with more colour for the foreground area of the lane.

16. Apply ox gall on either side of the lane to indicate tyre tracks – note how the pigments move away from the sides of the brush strokes.

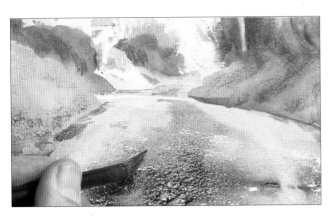

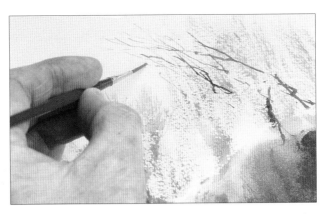

17. Mix burnt sienna and ultramarine, then define the ruts in the sides of the lane. Define the raised middle section of the lane with the same mix.

18. Finally, use a rigger brush and a strong mix of burnt sienna and ultramarine to define the small branches and twigs on the trees.

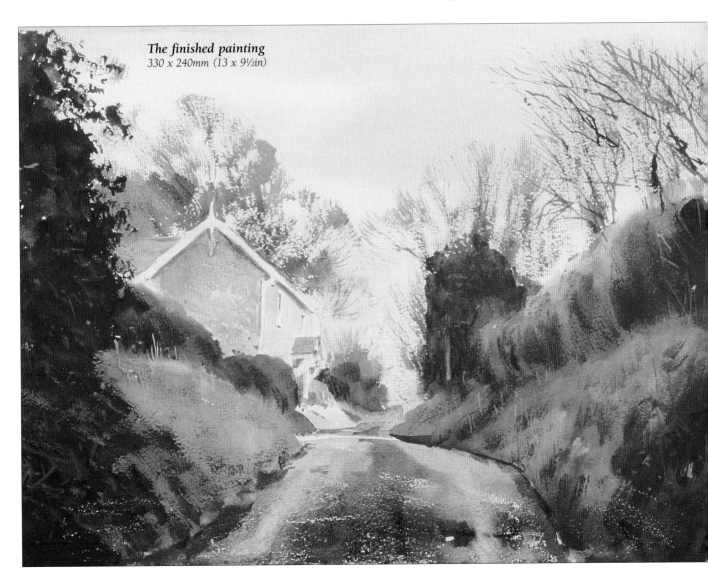

The finished painting
330 x 240mm (13 x 9½in)

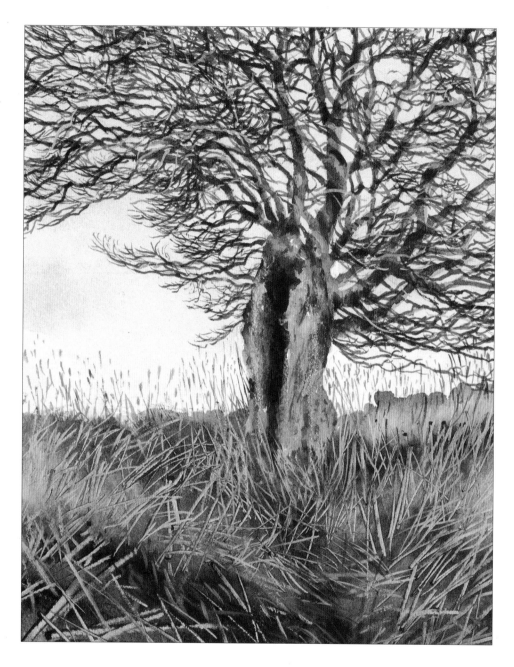

Lacework of Branches
265 x 340mm (10½ x 13½in)

The foreground grasses in this painting were scratched out while the paint was still wet. The best time to do this is just before the paint dries out – scratching out too early, when the surface is still very wet, will not work because the paint will simply flow back over the lines.

Opposite

Hoar Frost
250 x 340mm (10 x 13½in)

I used the sponging technique for lifting out the soft-edged highlight in the foreground water of this painting. I wetted a sponge with clear water, squeezed out the excess moisture then applied two or three strokes across the surface. For a thinner, soft-edged highlight, you could use an oil painter's bristle brush and, if you use it against a ruler, you can achieve good straight lines.

For really sharp, very thin white lines, such as the one across the distant water, cutting out is the most effective technique. I used a very sharp knife to lightly cut two lines, close together, into the surface of the paper. I then scratched out the paint from the strip between the lines.

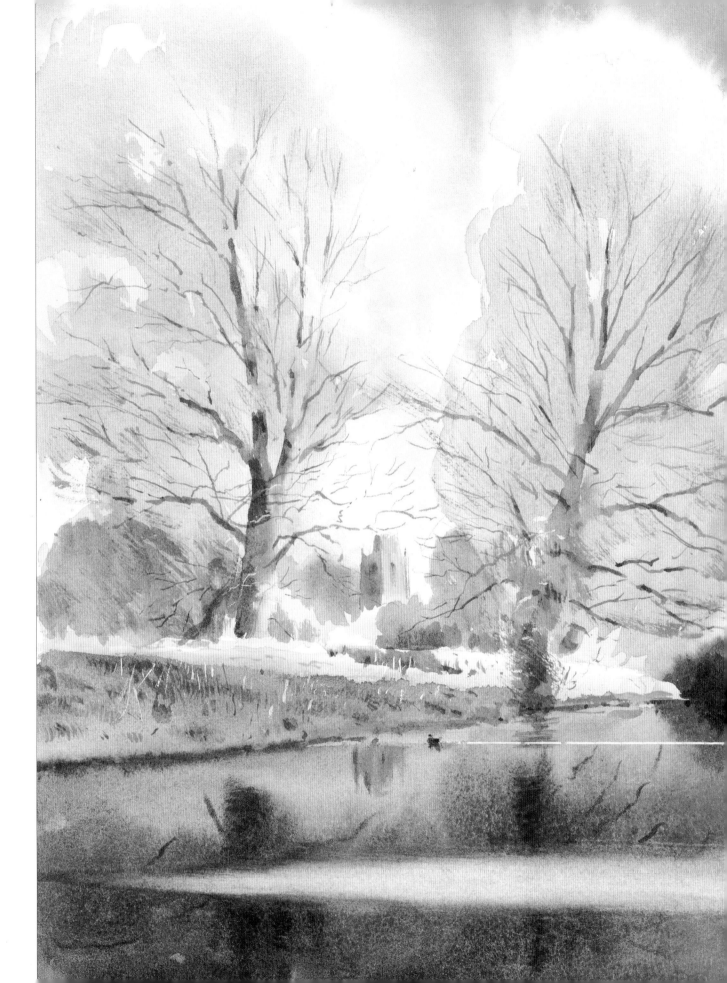

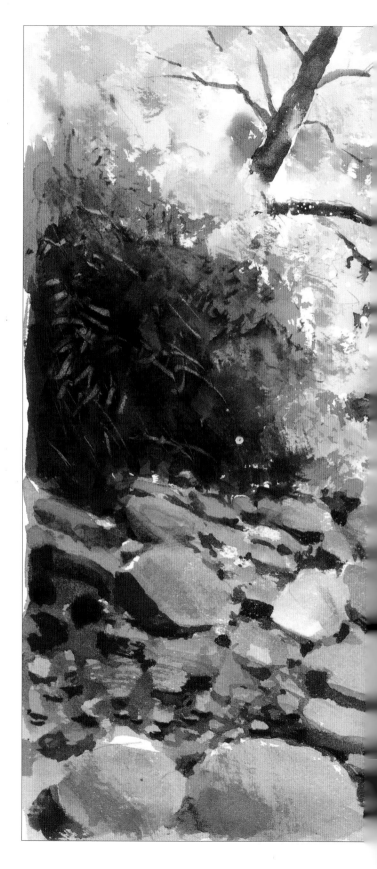

Rocky Riverbed

380 x 265mm (15 x 10½in)

This painting shows how the split-brush technique can be very effective for creating the ragged edge of foliage. I used this technique in conjunction with masking fluid, spattered into the background, to help create the quality of strong sunlight breaking through the foliage.

More subtle colours are used in the foreground. Alizarin crimson, ultramarine, cerulean blue, Indian red and burnt umber give variation of colour amongst the rocks. The rough texture on the foreground rocks is the result of rubbing the paper with a white candle prior to painting.

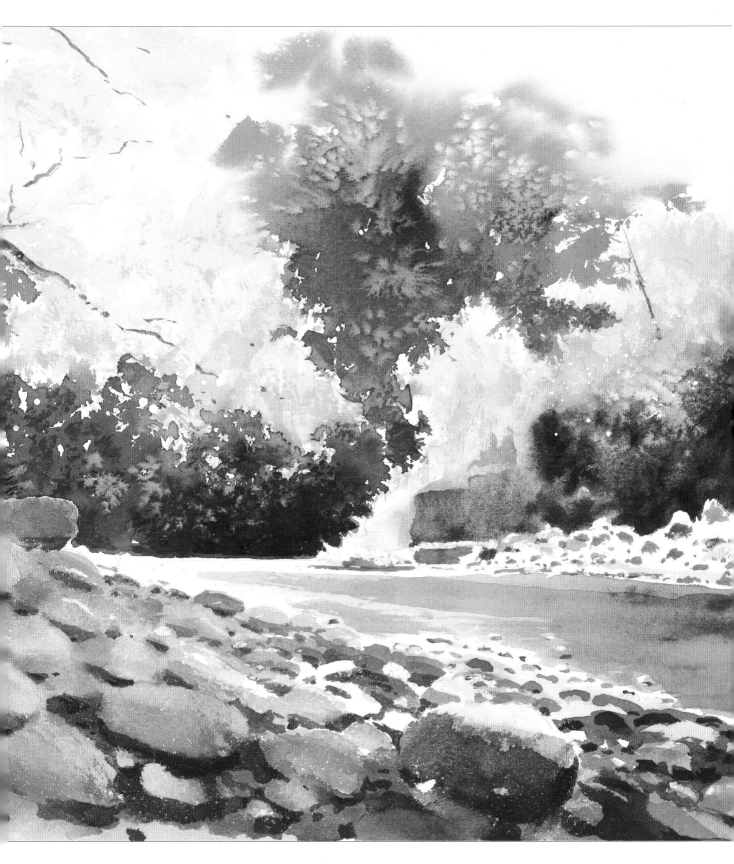

Index

Sunset on the Ouse
340 x 175mm (13½ x 7in)

Early evening is one of my favourite times of the day to paint river scenes. This dramatic skyscape was made by applying the clouds – a mix of ultramarine, alizarin crimson and burnt sienna – wet in wet on a background wash of raw sienna. The colours mixed on the paper to form the ragged edges. The same colours are echoed on the surface of the water.

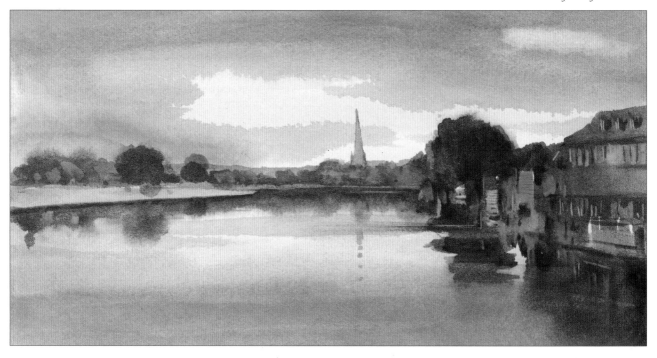